D0991493

PRINCIPLES OF NEO-PLASTIC ART

THEO van DOESBURG

PRINCIPLES
OF NEO-PLASTIC ART

WITH AN INTRODUCTION BY HANS M. WINGLER
AND A POSTSCRIPT BY H. L. C. JAFFÉ

TRANSLATED FROM THE GERMAN BY JANET SELIGMAN

NEW YORK GRAPHIC SOCIETY LTD.

PUBLISHERS' NOTE

THIS IS A TRANSLATION OF *GRUNDBEGRIFFE DER NEUEN GESTALTENDEN KUNST*
WHICH ORIGINALLY APPEARED AS VOLUME 6 IN THE *BAUHAUSBÜCHER* SERIES IN 1925
AND WAS REISSUED IN 1966 IN FACSIMILE (ORIGINAL TYPOGRAPHY BY LASZLO
MOHOLY-NAGY) IN THE SERIES *NEUE BAUHAUSBÜCHER* BY FLORIAN KUPFERBERG
VERLAG, MAINZ. IN AN EFFORT TO CONVEY SOMETHING OF THE TRUE FLAVOUR OF THE
ORIGINAL VOLUME, AN ATTEMPT HAS BEEN MADE IN THIS ENGLISH LANGUAGE EDITION
TO ADHERE AS CLOSELY AS POSSIBLE TO THE ORIGINAL TYPOGRAPHY AND MAKE UP OF
THE GERMAN EDITION.

SBN 8212—0320—7

LIBRARY OF CONGRESS CATALOG CARD NO. 68—31178

COPYRIGHT © 1966 BY FLORIAN KUPFERBERG VERLAG, MAINZ
ENGLISH TRANSLATION COPYRIGHT © 1968 BY PERCY LUND, HUMPHRIES & CO LTD
LONDON

PRINTED IN ENGLAND

PRINTED BY PERCY LUND, HUMPHRIES & CO LTD
LONDON AND BRADFORD

CONTENTS

THE BAUHAUS AND DE STIJL

Theo van Doesburg's *Principles of Neo-Plastic Art* appeared as the sixth volume of the 'Bauhaus Books' in 1925. Van Doesburg had designed the jacket himself but the typographical layout of the cloth binding and the pages of text and illustration were by Laszlo Moholy-Nagy. The book was dedicated by its spiritual father to 'friends and enemies'. A number of people doubtless already knew of its contents by hearsay and anyone who knew Dutch could have read the arguments. As we learn from a note dated 1924 which appeared over the imprint in the 'Bauhaus Book', Van Doesburg had completed the 'original manuscript' by 1917, from notes made in 1915; it had been printed in two numbers (Volumes I and II) of the philosophical journal *Het Tijdschrift voor Wijsbegeerte*. 'My purpose', continues Van Doesburg in his note, 'was to answer the fierce attacks made by the public with a logical explanation and a defence of the new plastic art. I owe it to my stay in Weimar and to the assistance of my friend Max Burchartz that this thoroughgoing German translation was made in about 1921–1922 I have simplified and revised many passages during the course of translation.'

Van Doesburg was at Weimar for about two years and his stay there occasioned a number of speculations about his relationship with the Bauhaus, with which, apparently, he was anxious to make closer contact, of which he was a rival and which he is supposed to have influenced. Relations – sometimes strained – did indeed exist. So strong was the fascination exerted by Theo van Doesburg that he gathered round him a few Bauhaus students – undoubtedly gifted men – who felt more powerfully drawn by talks with him than by the course. Forming as they did a Fronde, they were a fairly seriously disturbing factor and it was therefore not surprising that the Council of Masters of the Bauhaus looked upon visits to Van Doesburg with disfavour. Nevertheless, in matters of fundamental artistic importance there was a large measure of agreement between the two sides. That none of the views on art proclaimed by Van Doesburg and the De Stijl group was basically different or more advanced than those of the founder of the Bauhaus is demonstrated by a glance at Gropius's early buildings: the importance of the Fagus factory at Alfeld (1910–11) and the buildings at the Werkbund exhibition in Cologne (1914) and the key-position they occupy have never been in doubt.

Van Doesburg discusses the arguments which went on in Weimar during the 1920's between De Stijl and the Bauhaus in a letter written from Meudon on 1 May 1924 and addressed to Molohy-Nagy, with the request that it be passed on to the Council. In this letter – which is preserved in the Bauhaus Archive – Van Doesburg states in his somewhat awkward style – German was not, of course, his native tongue – that as soon as he had become acquainted with the Bauhaus and its artistic activity . . . he had been extraordinarily interested. 'In so far as its efforts ran parallel with similar efforts in Holland which had already been tried out in practical building, I wanted – although my purpose was not in the least personal – to take up the fight with my artistic work and my propaganda independently of the Bauhaus and to support the administration (of the Bauhaus) in its struggle.' When in 1920 Gropius first saw photographs of work by members of the De Stijl group, he recognized the convincing maturity of their achievements but at the same time stressed that he wished in all circumstances to keep the Bauhaus free of 'dogmas' so that everybody could develop 'his own creative individuality'. This showed that, although there was agreement on questions concerning art, there were differences in didactic method which promised a poor look-out for direct collaboration at the same teaching establishment.

Once settled in Weimar, Van Doesburg wrote again that his picture of the Bauhaus had soon been dimmed, for 'My home Am Horn and later my studio Am Schanzengraben became meeting-places for people who criticized and found fault most bitterly with the internal structure of the Bauhaus (of which I knew nothing). These critics were not only enemies of the Bauhaus but also friends, masters, pupils . . .' Instead of having to listen to troubles and gossip-mongering of an all too personal nature, Van Doesburg would have preferred to have held open discussions with the Bauhaus on questions of art. Everyone knew, he said, that, sharp though his criticism had been, it was 'aimed solely at purely artistic differences and differences over principle in the Bauhaus and that its starting-point had always been the basic programme and nothing else'.

There were, indeed, contradictions between Bauhaus programme and practice. Although Van Doesburg as an outsider could scarcely have known this, most of them resulted from the financial and political difficulties experienced by an institution dependent upon the state and upon the good will of a citizenry of largely conventional outlook. This explains the 'impossibility of achieving the collective

complete building', which required for its construction not only intellectual prepared-
ness, but also material conditions which simply did not exist. But Van Doesburg's
criticism did touch a tender spot in the inner administration of the Bauhaus when he
reproved it for allowing metaphysical speculation and religious sectarianism to
side-track or overlay the 'real problems of *Gestaltung*'. The special butt of this
criticism seems to have been Johannes Itten's circle. In the pathos of Expressionism
(which had, indeed, already been evident in the founding manifesto of 1919), the
Bauhaus had to some extent departed from aesthetic clarity and from the relevance
to both life and function found in the early work of its founder. Theo van Doesburg's
criticism supported Walter Gropius – who seems to have been totally unaware of
the assistance that was being proffered – in his attempts to realize, in the great
co-operative achievement that was the Bauhaus, those ideas which were most his
own and had preoccupied him since as early as about 1910, and on which he had
worked unremittingly since then. Van Doesburg's presence worked now to some
extent as a catalyst which precipitates reaction in a chemical substance but does
not amalgamate with it. Gropius remained entirely himself. There were only two
fields in which De Stijl examples palpably influenced the Bauhaus – typography
and furniture design. Thus Marcel Breuer's first chairs (these were still made of
wood) are formally derived from works by the Dutchman Rietveld. Nevertheless the
number of suggestive ideas which were actually turned to practical account is
small.

Important as was the critical self-consideration that was now going on in the
Bauhaus, the tremendous psychological tensions which in about 1921 had almost
burst asunder the combined ranks of teachers and pupils produced many inhibiting
effects but also far-reaching constructive ones. This should not be forgotten.
When Klee likened the Bauhaus to a 'play of forces' and praised it for being such,
he was looking upon it as a field of tension; similarly Muche in his reminiscences
calls it an 'accord' which he emphatically wishes to be certain is not confused with
smooth 'harmony'. This special ability of the Bauhaus community to heighten the
most specifically personal qualities of the individual members and to permit them
to develop – always to the advantage of the group – had evolved out of crises and
never failed to affect sensitive visitors who had the opportunity to look below the
surface. We may surely assume that – once the situation had been clarified – Theo
van Doesburg too sensed this and that it helped to persuade him to correct his

radical attitude towards the Bauhaus, which, as he stressed, despite certain individualistic features was certainly no 'academic sleeping-powder' and no 'artificial preserve tin'. Had he not respected the distinctive intellectual quality of the Bauhaus, it is difficult to imagine how – from the point of view of either side – his *Principles of Neo-Plastic Art* could have appeared in the series of 'Bauhaus Books'.

Other artists of De Stijl were in touch with the Bauhaus in the way of collaboration. Mondrian had a large coloured lithograph printed at the graphic printing works of the Staatliches Bauhaus; Oud gave a lecture on 'The development of modern architecture in Holland' on the occasion of the 'Bauhaus week' in August 1923. Both wrote 'Bauhaus Books' – Mondrian a volume of essays on *New plastic art*, Oud a collection of short studies entitled *Dutch Architecture*. It was a matter of course for the friends of the Bauhaus in the De Stijl group to stand out solidly for the Bauhaus when it was slandered and attacked. But even then, for all the friendly understanding, the possibility of distance was taken for granted. For despite everything they had in common, De Stijl and the Bauhaus were and remained opposed to one another in one all-important essential. De Stijl, as its name implies, demanded style, stylistic form, an entirely specific mode and manner of artistic manifestation which, it was hoped, would gain universal allegiance. Gropius and his fellow combatants rejected any fixation upon one stylistic theory and had no wish to create a 'Bauhaus style'. To the teachers at the Bauhaus it appeared more important than formal results that their pedagogical work should succeed in developing the personality in the awareness of its responsibility to art, a responsibility which was also to be regarded as social.

As editor of this book I thank Frau Nelly van Doesburg (Meudon), who has continued to promote her husband's ideas, and Professor Jaffé (Amsterdam), the interpreter of De Stijl, for their advice and active collaboration.

H. M. WINGLER

Theo van Doesburg's signature

THEO VAN DOESBURG

REPORT OF THE DE STIJL GROUP
vis à vis the 'Union of International Progressive Artists'
at the 'International Artists' Congress' in Düsseldorf,
29 to 31 May 1922 (fragment)

I. I speak here for the De Stijl group in Holland which has arisen out of the necessity of accepting the consequences of modern art; this means finding practical solutions to universal problems.

II. Building, which means organizing one's means into a unity (*Gestaltung*) is all-important to us.

III. This unity can be achieved only by suppressing arbitrary subjective elements in the expressional means.

IV. We reject all subjective choice of forms and are preparing to use objective, universal, formative means.

V. Those who do not fear the consequences of the new theories of art we call progressive artists.

VI. The progressive artists of Holland have from the first adopted an international standpoint. Even during the war . . .

VII. The international standpoint resulted from the development of our work itself. That is, it grew out of practice. Similar necessities have arisen out of the development of . . . progressive artists in other countries.

(Printed in *de Stijl*, Volume V, 1921–2, page 59)

THEO van DOESBURG

BAUHAUS

GRUNDBEGRIFFE DER NEUEN GESTALTENDEN KUNST

BÜCHER 6

DEDICATED TO FRIENDS AND ENEMIES

The original manuscript was completed in about 1917 from notes made as long ago as 1915 and printed in 'Het Tijdschrift voor Wijsbegeerte' (*Journal of Philosophy*, Vols. I and II). My purpose in writing it was to answer the fierce attacks made by the public with a logical explanation and a defence of the new plastic art. I owe it to my stay in Weimar and to the assistance of my friend Max Burchartz, that this thoroughgoing [German] translation was made in about 1921–2. I tender him my most hearty thanks! I have simplified and revised many passages during the course of translation.

Paris 1924.

INTRODUCTION

One of the most serious of the many reproaches levelled against modern artists is that they address themselves to the public not only through their works, but through their words as well. Those who reproach the artist for so doing forget, first, that there has been a shift in the relationship of the artists to the community – a shift, that is, in social consciousness – and, second, that the fact that the artist writes and talks about his work is the natural outcome of the general misunderstanding of the manifestations of modern art on the part of the laity. Because the *works* lie outside the limits of the awareness of many contemporaries, it is they themselves who beg the artist to explain them. These questions – be they seriously or ironically intended – have made it a matter of conscience for artists to intercede verbally on behalf of their works.

This is the source of the misconception that the modern artist is too much of a theoretician and that his work springs from *a priori* theories. In fact, precisely the opposite is the case. The theory came into being as the necessary consequence of creative activity. Artists do not write *about* art, they write *from within art*.

The upshot, in fact, has been this: the artists have required of their artistic theory the same as they have required of their work: *exactitude*. It

is this that has given their utterances their rigorously abstract character. This is a gain which ought not to be underestimated, yet it has the drawback that for most laymen this kind of introduction is almost as difficult to understand as the work itself. Consequently this manner of elucidation failed of its practical purpose.

Responsibility for present-day non-comprehension of the visual arts lies as much with the artist-theoretician as with the observer: the observer, because art is for him a matter to which he probably does not give so much as a few moments' thought daily and because from the first he has had no doubt that art gives pleasure but demands no effort whatever.

The artist-theoretician, because only rarely is he concerned with anything apart from art and he takes the point of view that it is not for him to descend to the level of the public (which is, of course, unnecessary, indeed impossible, where his creative work is concerned), but for the public to aspire to his.

Yet how is the public to lift itself to the artist's level if the artist does not help; if, in other words, the artist does not help the public to see, hear, and understand his works.

The public has its own, proper interior and exterior worlds, the artist has others. The two differ so greatly that it is impossible to pass from the one to the other.

The artist speaks from within his interior and the exterior worlds in words and images which come easily to him because they are elements of the world in which he alone belongs. The public's worlds, however, are totally different and the words with which it expresses its ideas are entirely characteristic of its own world.

The perceptions of different people, each of whom inhabit different interior and exterior worlds, clearly cannot coincide. Examples will follow. Suffice it now to show how even a single phrase used by people of different environments gives rise to totally different interpretations.

The modern artist uses the phrase 'space formation' in order to enable the observer to look at his work. The artist whose occupation consists in space formation and is closely involved with it, regards this expression as as much a matter of course as does the surgeon the word fracture. The layman, however, has totally different conceptions of space and formation. At best he takes 'space' to mean a hollow or a measurable surface. The word 'formation' will awaken in the observer an uncertain memory of a physical shape. The combination of the two words 'space' and 'formation' will therefore convey to him a physical form having spatial depth and shown in perspective in the manner of the artists of the past.

To the modern creative artist space is not a measurable, delimited surface, but rather the idea of extent which arises from the relationship between one means of formation (e.g. line, colour) and another (e.g. the picture plane). This idea of extent or space touches the fundamental laws of all the visual arts because the artist must understand its principles. Furthermore, space means to him a special tension created in the work by the tightening of forms, planes or lines. The word formation means to him the visible embodiment of the relationship between a form (or colour) and space and the other forms or colours.

As we can see, the two interpretations differ greatly. If, as this suggests, there is so great and fundamental a difference between the artist and the layman in their understanding of *a single phrase*, it will be impossible for the layman to grasp those numerous concepts which would enable him to advance towards an understanding of the work of art itself.

This, however, applies not only to the layman but also to those concerned in one way or another with the visual arts.

If confusion of ideas in the terminology of the visual arts were the sole cause of lack of understanding and misinterpretation, the remedy would be easy; unfortunately, however, there are other difficulties which hinder understanding.

8

Another cause must be sought in the following fact: since the old ideas of the visual arts have become outmoded and are no longer valid, a new groundwork of ideas is needed, or, perhaps, a new system of instruction to give the layman a new point of view and to clarify his ideas or completely reconstitute them. Just as Spanish flies are no longer prescribed in medicine, so in painting it has become impossible to cling to a Vitruvian hypothesis.

> Vitruvius says in the Sixth Book of his work on architecture: 'A painting is the representation of a thing which exists or which can exist, e.g., a man, a ship or other things for which rigidly outlined physical forms have served as models.'

Experience proves that this idea still persists, both among laymen and among many artists too. With so primitive a conception of art many good articles and books about the new visual art must inevitably fail to bring proper results●). All these studies (most of them by art-historians) evince too personal an interpretation. These writings are the products of a system of thought and feeling which has an individualistic bias and as such are not suited to elucidate a creative principle rooted in universality. Personal interpretation of the various expressional forms of the new visual art must be replaced by a synthesis of its nature, which alone can answer the purpose.

One of the most significant points of difference between it and earlier concepts of art consists in the fact that in the new art the artist's temperament is no longer so prominent. The new plasticism is the product of a universal stylistic intent.

Daily intercourse with serious modern artists has convinced us that they are not concerned to bring their personalities to the fore or to force their personal ideas upon any one. Basically, their sole purpose is to produce works which shall be as good as possible; and to draw closer to the public through their writings so as to promote mutual understanding

●) The works which have appeared in Germany, France, Italy and America on the new visual art amount to a considerable volume of literature on this question.

between the artist and the community. Obviously this cannot be achieved without great difficulties, but these could be overcome were it not for a third cause which makes it almost impossible for the artist to address himself to the public, either directly through his work or indirectly by explanation.

This third cause is official newspaper criticism. It derives from the extremely sketchy and subjective impressions of a few, mostly unintelligent, lay people who possess an outmoded or hazily modern conception of painting. What this criticism lacks is method. When criticism of works of art lacks method, confusion must inevitably arise over the meaning of the modern visual art – for the personal impressions of Messrs A. and B. can render the public but little assistance.

We have already repudiated this habit of reviewing works of art instead of elucidating them. Those who enjoyed doing so we called lay critics, not in order to offend them, but to define their true relationship to art and to the public.

This type of art review should be rejected. First, because the artist, rather than the work of art, becomes the object of the review and secondly and, indeed, mainly, because a universally acceptable concept of 'formation' (*Gestaltung*) and 'art' – and therefore any critical method – is alien to all these critiques.

The modern artist desires no intermediary. He wishes to address himself to the public directly, through his work. If the public does not understand him it is up to him to provide his own explanations.

The main reason why the public is on the wrong tack where the new art is concerned lies in the irrelevance of lay criticism, which obscures with unclear clarifications the unprejudiced vision and experience of works of art.

There is only one way to restore the unprejudiced way of looking, destroyed by the ignorance and complacency of traditional art criticism: **elementary and universally intelligible principles of visual art must be established – which is what is attempted here.**

FIRST CHAPTER

THE NATURE OF VISUAL ART

I. Everything that surrounds us is an expression of life. Every living thing experiences its environment consciously or unconsciously.

Various philosophers and biologists (Descartes, Darwin, Kant, Von Üxküll and others) have proved experimentally that the higher a living creature in the scale of organisms the more conscious will be its experience, the lower its place in this scale the less conscious will it be. Thus we call the vital consciousness of the humbler living creatures mere instinct but that of the higher creatures, like man, understanding, reason, and intellect.

Jean-Jacques Rousseau has shown in his *Emile* that the experience of an individual creature undergoes a specific evolution and that this evolution of experience corresponds to the growth of the man from childhood to adult life.

Example 1

A child, having as yet no experience of space, reaches for distant things, e.g., the moon. Only gradually does the child sense (by grasping, running, etc.) that certain things are near, others distant. Thus it will learn which objects are 'close to' and which 'far away' and will itself come to experience space and its relationship to him (the child).

II. Consciously or unconsciously every creature turns its experience of life to use.

Experience of life is thus practical and, in so far as this practicality is related to material conditions, the individual will be capable of reacting

practically upon his environment, of acting to practical purpose and of developing. First experiences are of a *sensory* character.

Even primitive man makes practical use of these experiences. As material demands are gradually met, perception, which was at first exclusively *sensory* begins to *deepen*. From this deeper view of life springs an experience of a deeper kind: psychic experience●).

As soon as an individual, after many experiences, becomes capable of *distinguishing* between them, *comparing* one with another, *connecting* and *organizing* them, *intellectual awareness* combines with vital perception. Experience of the environment then becomes more conscious, more rational, more *intellectual*.

III. Within the experience of reality as undergone by all organisms from the simplest to the most highly evolved individuals we may distinguish three types of experience:
 (a) sensory (seeing, hearing, smelling, tasting, feeling),
 (b) psychic,
 (c) intellectual.

These three types of experience cannot be completely separated, yet when one predominates it determines the relationship of the individual to his environment.

Example 2

Thus we may clearly observe that a dog's experiences are of the sensory kind. His range of experience is limited to sensory perception (smell, hearing, etc.) We may call this a sensory, materially practical perception. The dog reacts to his environment through his senses. If an object be held in front of him which demands *other* than a purely sensory *perception* (e.g., a book, a picture) this object will interest him not at all or only through his senses (e.g., in so far as he can smell it). If the experience he

●) One outcome of this spiritual experience is religion.

undergoes does not correspond to his material needs, the object leaves him cold. Because he is restricted by the limits of sensory experience, all objects which call for a deeper perception will lie outside his 'world' and will therefore simply not exist for him•), whereas a sausage would immediately awaken all his faculties of perception.

IV. Perception and vital experience mutually determine one another.

If the perception is external, sensory, so too is the experience external, sensory.

If the perception is more inward, psychic, so too is the experience more inward, psychic.

If after an experience of the senses (e.g., in the presence of an object) a process takes place in the *psyche* (during or after apprehension), we can say that this experience is not merely a sensory one. In this case the sensory experience is only a means to a deeper experience of reality.

If as a result of this process an even deeper experience of reality ensues, so that the individual is *rationally aware* of its content, we have an *intellectual* experience of reality.

The reaction of the vital experience corresponds to the character of the vital experience.

V. If the vital experience is intellectual, i.e. if experience of the environment is not exclusively restricted to the sensory or the psychic, the reaction will correspond to the vital experience.

The individual will react to the environment differently from the dog in Example 2. The dog reacts in a purely material, practical manner.

•) From this we may conclude that there is no positive reality. 'Reality' for each individual is only his relationship with his environment; and in fact his relationship is determined by the limits of his possibilities of experience.

Sensory, psychic or intellectual experience of reality may be either *passive* or *active*. If an experience evokes an outward reaction we call it active, if it does not evoke reaction we call it passive. The deeper (psychic and intellectual) experience of reality may, if the experience is active, produce the impulse to objectivize the experience in material shape, i.e., to form (*gestalten*).

VI. The essence and occasion of all art lies in this formative reaction of our active experience of reality.
VII. The work of art is the expressional or formative aspect of this intellectual, active experience of reality.

The intellectual *active* experience of reality is *aesthetic*. The intellectual *passive* experience of reality is *ethical*.

SECOND CHAPTER

THE AESTHETIC EXPERIENCE

Art is therefore the expression which corresponds to our purely aesthetic experience of reality.

We may conclude from this that when the content of the artist's active experiences is aesthetic, the expression of these experiences must have a similar content.

VIII. The content of all arts is the same. Only modes and means of expression are different.

Visual art, for example, is the exclusively plastic expression of the aesthetic experience (using space, volume, colour), music the exclusively phonetic expression of the aesthetic experience (using time and sound), etc.

IX. Aesthetic experience and expression of the experience mutually determine one another.
X. The aesthetic experience is expressed in relationships.
XI. These relationships become apparent within the expressional means proper to each form of art.

The expressional means of the various arts arise out of the contrast between positive and negative elements.

The organization of relationships (positive and negative) with one another as determined by aesthetic vision is the essence of creative activity.

XII. The most powerful expressional form of any art is achieved by using only the means proper to each.

If the formation of the aesthetic experience of reality is kept within the bounds of the expressional means proper to each art, each branch of art is pure and genuine in itself (see Fig. **1–4**).

If the bounds of the expressional means proper to an art are over-stepped the form of art will be impure and not genuine.

Thus the pure expressional means of music is: 'Sounds (positive) and non-sound' (negative). The composer expresses his aesthetic experience through relationships between sounds and non-sound.

The pure expressional means of painting is colour (positive) and non-colour (negative). The painter expresses his aesthetic experience through relationships between coloured and uncoloured planes[1].

The pure expressional means of architecture is plane, mass (positive) and space (negative). The architect expresses his aesthetic experience through the relationships of planes and masses to internal spaces and to space.

The pure expressional means of sculpture is volume (positive) and non-volume or space (negative). The sculptor expresses his aesthetic experience through the relationships of volume to space (within a space)[2].

These and other arts (poetry, the dance, theatre, and film) are the forms we give to aesthetic experiences of reality.

Example 3

We may conclude from Point **III** that not everyone experiences the same things in the same way.

A farmer will see a cow in its capacity as an animal for breeding and as a milk-producer; his view will take into account only the usefulness of

[1] We call 'colour' all the bright tones (or, to be more precise, red, blue, and yellow); 'non-colour': black, white, and grey.

[2] Thus to break down the artistic means into a positive and a negative element serves only as a means of defining as exactly as possible the essential values of the expressional means. This duality can obviously be resolved in the work of art. Creative activity can bring about an interchange between the two. This means: the negative element, e.g., non-coloured planes in painting, can become positive and thus *equal in value* to the contrasting element (in our example, colour).

Formation (*Gestaltung*) is essentially: **the balancing of positive and negative to achieve exact harmonious unity.**

the animal for breeding and for milking; when the farmer calls the cow 'beautiful', this 'beautiful' refers to the well-cared for appearance of the animal, its health, milk-producing qualities, size, etc.

The veterinary surgeon has a different view: he will be mainly interested in everything that concerns the cow's state of health. He sees the animal from the point of view of the anatomist, the physiologist, etc. When he praises the animal it means that the cow is healthy, strong, well-built, etc.

The cattle-dealer sees the cow as a commercial commodity. When he praises the animal it means that she will be a good seller and a profit-maker.

The butcher sees the cow primarily as so many pounds of meat, so many pounds of fat and x pounds of bones.

Thus each of the various people looking at the cow sees her in a way which is related to his occupation and his talents. The personal experience of each determines for him the 'reality' of the cow●).

The painter sees but few of these features; certainly he too has a definite experience of his object, but it concerns other qualities in the animal; more general ones than those which strike the farmer, the cattle-dealer, the veterinary surgeon, etc. More general, because he perceives the same features in other objects too, although in entirely different relationships.

The formative artist sees the cow also in combination with open space, the play of light on her flanks, he experiences the hollows and the prominences as **sculpture;** he sees the parts of the body between the forelegs and the hind-legs not primarily as belly or breast but experiences them as **tension.** He sees the ground on which the animal stands as **plane.** He sees

●) If we were to adopt the philosophical standpoint we could say: the sum of the various relative experiences would express the absolute reality. This, however, lies beyond the range of experience available to the artist. Since our book is concerned with tracing only the aesthetic reality, we will concern ourselves no further with the philosophical side of the enquiry.

no details, since particular features of the object do not interest him. The artist experiences animal and environment in organic cohesion. Should the animal begin to move, there will be new experiences for the artist. He observes a definite periodicity and a repetition of unequal movements which he experiences as **rhythm.** The body of the animal, which the artist need no longer remember as such, seems to him to multiply in space because of these movements. Not as a physical creature, but abstractly in the formative imagination of the artist.

The laws of creation are apparent in the aesthetic or formative vision; in visual art, for example, the balancing relationships of mass, colour, space, etc. We call these relationships **aesthetic accents** and to a greater or lesser degree every artist regards them as the most essential element in his work, in so far as he is concerned with visual art and nothing else.

XIII. The stronger the aesthetic experience the more completely will the objective, natural appearance of the object of the experience be annihilated.

This means: (in terms of our example) the cow as draught-animal, as source of food, as product for sale; in a word: the natural animal disappears and becomes for the formative artist a complex of formative aesthetic accents, in colour-relationships, formal relationships, contrasts, tensions, etc. The fact that the environment which surrounds the animal (ground, air and background) belongs also to the complex of these relationships constitutes another difference from the manner in which the veterinary surgeon, the farmer, etc., see the cow. For them, the ground and the things in the environment of the object of the experience do not form a whole with the cow – at least, not an organic whole; for the artist, however, they do; in the formative vision everything is equalized, i.e., enters into relationships, because by their nature the artist's experiences synthesize.

18

XIV. In the aesthetic experience individualistic difference becomes organic indifference.

This means that things which are objectively separate become aesthetically unified (in our example, the cow and the ground on which she stands).

XV. The aesthetic experience is an experience of all the artist's creative powers.

In the aesthetic experience sensory perception – in pictorial art visual perception – is merely the means to the experience. The senses establish *direct contact* with reality. The artist's psyche works upon the impression which has been picked up and transforms it so that it appears in the mind not in the manner of nature but in the *manner of art*. A transfiguration takes place between the sensory impression and the aesthetic experience. *The natural phenomenon is reconstructed in aesthetic accents which re-embody the essence of the object in a new way*[1] (Fig. **5, 6, 7, 8**[2]).

Thus the artist experiences reality aesthetically and only when this experience accords with his whole nature can we say that he has by aesthetic means reanimated reality.

The aesthetic experience obviously includes sensory and psychic experience (see Point **IIIa** and **b**). Sensory and psychic experience does not include intellectual experience.

[1] We have said enough to make the difference between 'form-giving' (*gestalten*) and 'imitating' abundantly clear. We may also use the phrases 'to re-create' for the first and 'to repeat' for the second.

[2] My reconstructions of natural objects (see Fig. 6, 7, 8 and 14–17) are adduced only in order to illustrate the creative process. It is not, therefore, the intention to elevate this manner of representation into a dogma or to call for a similar reconstruction for every work of art. In order to avoid misunderstanding it should be expressly stated that the method of reconstruction was only our means to an end. It becomes superfluous, however, when the artist's aesthetic experience rests only on relationships and ratio. This transfiguration which is demonstrated here by means of forms borrowed from nature takes place in the creative consciousness of the artist. Thus it will also be clear that the creation of relationships by the use of elementary artistic means is not abstract but 'real'. Only during a period of transition was there question of an 'abstract' art in connexion with a representational manner of artistic creation.

If an artist's experience is predominantly aesthetic, aesthetic accents●) will also preponderate in his formative embodiment of the experience.

If other components find their way into the aesthetic experience, e.g. feelings of liking or dislike, feelings of pity for the object of the experience, the aesthetic experience will be weakened, sometimes even destroyed. This relegates the aesthetic accents to the background, the experience has a different content and the work of art a different significance, no longer a purely aesthetic one. We shall return to this in the chapter 'On looking at works of art'.

XVI. The aesthetic value of a work of art depends upon the degree of distinctness of the aesthetic accents.

If the aesthetic accents are weak, indistinct or lacking altogether, or if they are replaced by other accents, the work accordingly loses in artistic significance.

If, however, the aesthetic accents appear clear and unalloyed – if there is, let us say, a balanced relationship of two formative elements, e.g., colour and space, form and colour, etc. – and if these aesthetic accents are organized into a formative unity, tied to nothing other than the expressional means of their branch of art, we may say that the work of (visual) art is 'exact' (Fig. **9–11**).

●) The answer to the question, how does the artist arrive at these aesthetic accents, is: through an interplay between subject (the artist's mind) and object (reality). While it can be taken for granted that the artist will in future need no specific objective theme for the individual work of art, it must be emphasized that *all* works of art must be indirectly based upon experiences of reality.

THIRD CHAPTER

THE MIXED AESTHETIC EXPERIENCE

Earlier artists too allowed the aesthetic accents to dominate some-times to a greater, sometimes to a lesser, extent. The degree of aesthetic accentuation depends upon how pure the aesthetic experience is and upon the degree of the artist's ability (technical skill) to form these aesthetic accents into an aesthetic unity.

If during the aesthetic experience the artist is deflected by other properties of the object, the aesthetic accents will become indistinct; they recede into the background. In this way the artist fails to achieve a clear expression of the aesthetic experience.

When this occurs, as it so often does in painting, we may describe the experience in pre-exact painting●) as a mixed aesthetic experience.

Example 4

If a painter meets a beggar and is humanly aroused by *empathy* for the man's pitiful condition, he may translate this experience of poverty into an image tied to the phenomenon of a man in rags.

In this manner a typical picture of poverty may arise which can never-theless have little or nothing to do with artistic formation. Little, if the aesthetic accents are almost non-existent in the work, nothing if the aesthetic accents are replaced by others, e.g., ethical, emotional or social. Even when the aesthetic accents are strongly present *but tied to the description of the man's condition*, this mixed experience gives rise to a mixed artistic creation which lies midway between nature, imitation and art.

●) Pre-exact: painting up to the twentieth century.

We may say of such a case: the aesthetic accents appear *indistinct* (Fig. **12** and **13**).

The painter has used painterly means to tell us something about the man's poverty. He will be able to evoke the same response with other means too, e.g., with words.

If the artist's relationship to the object of his perception is strongly or largely aesthetic, feelings of liking and dislike (the personal and individualistically human element) will give way more fully to universal aesthetic accents. The painter in his work of art will lay the stronger emphasis not on the *emotional* but on the *aesthetic* accents●). The exclusive business of the process of artistic formation is to organize them into a unity. In our example too the painter will exaggerate the aesthetic accents in the figure of the beggar.

The exaggeration can be seen from the fact that *greater stress* is laid upon the space and colour values. The artist will expose universal cosmic relationships and values (balance, position, dimension, number, etc., which are obscured or veiled by the accidents of the individual case) not by empathy for the condition of the object of his perception but mainly by *abstracting* all the chance singularities of the object.

This is the point at which **illustration** (imitation) ceases; here begins aesthetic **transformation** (representation) into another reality; a reality deeper than the momentary, special, arbitrary reality, a *cosmic reality*.

This is the way in which all works of art which have an effect upon the development of visual art have come into being. In these works the aesthetic accents outweigh all others.

If the artist wishes to go further, if he wishes to accept the consequences of aesthetic formation so as to be able to express the aesthetic idea with exclusively aesthetic means, he will have to find a new, purely

────────

●) Various works by Van Gogh will serve as examples.

22

aesthetic form for the object of this perception. If he wishes to find a new purely aesthetic form he will be obliged to reconstruct the object of his perception (Fig. **14–15**). He will take the object of this perception back to its elementary *spatial manifestation*, strip away all arbitrary features, simplify it and re-express it in artistic relationships.

In this way the artist himself creates the aesthetic accents by using appropriate means: colour planes and plastic space in painting, volume and three-dimensional space in sculpture, etc.

The aesthetic accents now emerge clearly, they are free of ties and are assembled in the work of art into a unity which gives form to the aesthetic idea●).

It is at this point that transformation ceases (first imitation, then representation and finally formation) and exact formation with exact means begins (see chapter 'Expression and expressional means of the aesthetic experience') (Fig. **16–17**).

The artist is also expressing reality in this formative abstraction, but in a different way, that is, in the *way of art* and it is, indeed, a deeper reality that that which was expressed in imitation of the discovered object of perception.

By a process of formation with purely aesthetic means the artist gives reality a new shape.

This is the point to which visual art has developed in our time.

●) In this process of assembling there is still, of course, room for spiritual intuition, assuming that the artist does not wish his work to degenerate straight away into desiccated abstraction.
Spiritual creative intuition must, however, always be subject to rational control.

FOURTH CHAPTER

EXPRESSION AND EXPRESSIONAL MEANS OF THE AESTHETIC EXPERIENCE

If we look attentively at early works of art, we shall be struck by the fact that even in the most primitive drawings there are two differing styles of expression. These modes of expression correspond to the differences in the outward form of the reality. One consists in a mode of expression which is confined entirely to externally perceived objects or phenomena, and the other in a profounder mode of expression in which the externally perceived objects serve only to suggest thoughts or feelings.

In the first instance the object is the goal of the mode of expression, in the second only the means. Thus we may briefly label the first mode: 'Expression of matter', the second 'Expression of idea' (Fig. **18–19**).

At periods when the view of life has been materialistic, art has been materialistic too. All it has done has been to imitate the material aspect of objects. At periods when the view of life has been more inward, natural, external forms have been used only as auxiliary means for expressing an idea or a feeling (see First Chapter, Points **III–V**).

Materialistic art is entirely restricted to physical forms, it awakens in us an idea of the material beauty of these forms. Ideal art uses these forms, certainly; but it uses them as a vessel for ideas or emotions, in order to awaken the experience of a more inward beauty.

Leaving aside the question as to how far materialistic painting●) is art, it is clear that ideal painting is a more valuable kind of artistic expression

●) We might also use the terms imitative and creative art.

(assuming that the aim of art lies beyond the repetition of the outward form of things having a real existence in nature).

In the course of its development, visual art has increasingly striven to transcend exact reproduction of perceived objects and external forms. Art has followed many trails in its endeavour to win a territory exclusively its own, but artists have not been alive to the fact that art can attain its goal only *on its own ground*.

The primary goal of art is to be art. Visual art has to form (*gestalten*). Every objection raised against this statement can be met with its logical reply if we associate ourselves with the concept of *Gestaltung* (formation) and ask what art has to form.

Formation is direct, unambiguous expression realized by pure artistic means.

The content which has to be formed is the aesthetic experience of reality. (Artistic balancing of all the formative values.)

Form is related to the content it expresses as the body is to the psyche.

As soon as art deviates from its nature and ceases only to 'embody' formatively, but illustrates, i.e., gives direct instead of indirect expression to the aesthetic experience, it becomes impure and loses its unambiguous power.

Every work of art is preceded by an inward or outward experience of reality as dictated by the vital consciousness. The ideal and the material forms of expression correspond to the two modes of experience.

In materialist art perception is confined to the object; in ideal art perception has transcended this limit. This depends on a people's attitude to life, whether it is predominantly superficial (natural) or more profound (spiritual).

We observe that among the Egyptians art was predominantly ideal. Forms and colours are determined by the degree of inwardness of the vital consciousness; forms and colours become more definite and more basic.

Accidental nuances and details are suppressed. Tension arises in the outlines and clarity in the colours. The relationships of the basic forms replace the arbitrary phenomena of the individual natural forms (Fig. **20**).

Materialist art prevailed among the Greeks (Fig. **21**). The external forms of nature replace the basic cosmic forms. This is due to the fact that the vital consciousness of the Greeks was very closely tied to the outward forms of nature. They wished to see their gods in bodily form before them, to see them, indeed, in highly idealized natural forms; symbolic distortions, such as occurred among the Egyptians, hardly exist with them.

Thus the art of the Greeks will find the approval of any like-minded people. The Renaissance and every civilization which is based upon physical and material principles demonstrates the truth of this.

In the Middle Ages, however, a new idea appears. Although it was a religious rather than an artistic idea, it still influenced the expressional form of art: forms and colours became tauter and deeper, the psychic element (because, indeed, the prevailing attitude was religious) is curtailed. Contour becomes angular and rigid, colour more definite (Fig. **22**).

The religious principle is in fact another form in which fundamental reality is expressed. The duality of this reality is symbolized in the Christian religion in the antithesis God-Devil (Christ-Judas, position and counter-position).

Whereas classical art expressed the fundamental essence of existence *indirectly* through religious symbols, later developments in art show that its aim is to do so *directly●*).

If we assume on historical and genetic principles that the aim of art is **to give form to the fundamental essence through artistic means and nothing else,** it follows automatically that we cannot regard all ideal works as works of art.

━━━━━━━━━

●) If art does in fact form unity, harmony, it will embrace all kinds of feeling, including religious and ethical.

To do so notwithstanding is a danger which leads to a wrong attitude towards art.

Although we may assume that a piece of sculpture or a painting which arises out of an idea is nearer to a work of exact artistic formation, it is clear nevertheless that works are not to be regarded as works of formative art if they do not have an artistic idea as their starting-point. If an idea expressed in a work stimulates us in some way or other this is not to say that the work is a work of formative art. To say that 'everything which excites us and which is made with the intention of so doing is art' leads to the most absurd consequences, in fact to arbitrariness (the Baroque) and dilettantism.

When we are stimulated by a work, it always depends upon the *nature of the stimulation* whether the work is truly *formed* by aesthetic means.

This applies too to the ideas expressed in the work. They may be of a totally different kind, they may stimulate us and still the work may have nothing at all to do with art in the fundamental sense.

I have learnt from personal verification that most people, including those who understand art and artists, as well as lay people, remain unmoved in the presence of true works of art while other works stimulate them (by association of ideas, etc.).

Example **4** in the Third Chapter provides the reason. It lies in the manner in which the artist perceives the object of his experience.

Summarizing the various ideas that have been developed on this point, we may say that the aesthetic accents are alone relevant for the artist and that only when these alone prevail in him is his work aesthetic in character.

Having formulated the term 'aesthetic' to designate the idea of the real fundamental essence, we shall have no difficulty in recognizing that unambiguous embodiment of this idea is the basis of all art.

The aesthetic experience is thus a creative, active one in contrast to the uncreative, passive experience, as in our example of the beggar.

XVII. Only the active, creative experience can generate a work of art, not the passive.
XVIII. The passive experience can only produce a repetition or duplicate of the object of the experience.

Between these two poles of experience lies every possible degree, from art to non-art. The whole of artistic development towards the unambiguous embodiment of the aesthetic experience of reality moves between these two possible modes of experience.

The work of art emerges as reaction (see First Chapter, Point **IV**) from the active, creative experience.

The artist will also react strongly to a stronger creative experience. In order to be able to express the experience he will reach for the expressional means that will in fact realize his experience.

The expressional means will automatically be the characteristic expressional means of every art•).

When the artist repeats the object of his experience, stamping this duplicate with the mark of his temperament, this form of expression always remains to a greater or lesser degree inferior to the direct form of expression. This form of expression remains secondary, unclear, undefined.

It is not a direct realization, not an exact form of expression for the artistic idea, it is only a substitute.

XIX. The artist can produce a direct realization, an exact form of expression only through and from within his formative means.

The artistic idea is formatively embodied in every art through its own creative means as *material* (see Second Chapter, Point **XII**).

Art – visual art, music and especially painting – has to express the formative idea in its own way, with its own means. Obviously we cannot accurately describe the creative idea (the aesthetic moment). To clarify

•) In my work on aesthetics 'Die neue Gestaltungslehre' ('La doctrine de l'art nouveau') I have tried to reduce the elementary expressional means of visual art to a common denominator.

it we had used the words: state of balance achieved by placing and coun-ter-placing (e.g., vertical placed against horizontal), exchanging and cancelling out of dimension (e.g., large for small) and proportion (e.g., broad for narrow). It is the business of the artist to give form to all the accents of the aesthetic idea. It is of the essence of the work of art that these accents should appear to us in visible, audible, and tangible, that is, in concrete form. We call that work of art in which the aesthetic idea is expressed directly (i.e., by the expressional means proper to the art in question, e.g., sounds, colours, surfaces, masses) *exact* and *real*.

We call it exact in contrast to the work of art which attempts to express this idea by auxiliary means. Examples of auxiliary devices include any symbol or ideas, moods, tendencies which have emotional and intellectual associations●).

We call it real in contrast to the work of art in which the formative means are not merely the barriers of the organic unity of the work but have at the same time an illusionist, representational function (e.g., when colour is used in such a way as to produce an illusion of stone, wood, silk (materialism), a simulation of apparent depth or the simulation of the illusion of a piece of sculpture or architecture by painterly means, etc.).

It is not such auxiliary means that must realize the aesthetic experience, but the formative material itself: colour, marble, stone, etc. must be the direct bearers of the expression.

Should the artist use auxiliary means of this kind, the essential quality of the work of art, the realization of the artistic idea will be obscured.

────────────

●) By and large: objective *form*. When elementary expressional means are used objective 'form' becomes invalid. E.g., if the painter constructs his work with colour each form (be it naturalistic and illusionist or geometric) will only weaken the expression of the painterly or architectonic equilibrium. The same applies to sculpture, in short to all the arts.

What I mean here by 'form' appears in architecture as decoration. The decorative use of the elementary means, so common at the moment in the modern architecture of the Dutch and the Belgians, can only weaken the architectonic expression.

The development of the visual arts is at bottom a continuous process of approximation (irregular and erratic) to the exact and real expression of the formative idea. In the course of the development towards concrete means for this real expression, the material comes to occupy an increasingly prominent position. Thus sometimes in sculptures the unworked material remains visible and, indeed, forms a contrast to the representational forms which appear to grow out of it. This happened most often with the Impressionist sculptors (Fig. **23**). In Impressionist painting too the means become more apparent. In Impressionist and Post-Impressionist painting (use of bright, clear points of colour) the material appears as an *essential* part of the organism of the work of art, in contrast to the use of material in realist painting in which it is not an *essential part of the organism* but the means to an *illusionist reproduction* of the form, colour, and style of the subject represented and as such forfeits all its own significance.

To take two examples: Franz Hals and Rembrandt in their last periods, when they had come to experience the outward form of things more freely, that is, more creatively, and no longer clung anxiously to the object, gave freer rein to their creative impulses and expressed their artistic experiences rather by plastic use of the material (impasto, colour laid on broadly, brush-strokes remaining visible). The artist gradually woke up to the fact that the material could be used as the bearer of the content (Fig. **24**).

Every work of art shows whether the artist's relationship to his subject was an active, creative one or an imitative, dependent one. If the former, the artistic idea enters visibly into the work despite the fact that it is obscured by the arbitrary singularity of the subject. If the latter, the subject appears as the (apparent) double of the natural object.

The artist, and particularly the modern artist, sees nature creatively in that he gives form to his experience through pure artistic means, not arbitrarily, but according to the logical laws of his branch of art (these laws are the means of controlling creative intuition). He therefore uses

colours, wood, marble, stone, or whatever the material may be, as expressional means. Whether the artist creates a new aesthetic object, a work of art, depends upon his mastery of these means.

XX. If an object of experience as such enters visibly into the work this object is an auxiliary means within the expressional means. The mode of expression will in this event be inexact.
XXI. When the aesthetic experience is expressed directly through the creative means of the branch of art in question, the mode of expression will be exact•).

Example 5

When we look at old paintings, e.g., one by someone like Nicolas Poussin, we are struck by the fact that the human figures are portrayed in physical attitudes which we are unaccustomed to see in daily life, yet their corporeality is convincingly reproduced; the landscape too has clearly been improved. The leaves on the trees, the grass on the ground, the hills, the sky, all are true to life and yet the painter did not intend all this to be so. The attitudes and gestures of these people, the exact spot on which the individual figures stand and the relationship of the groups of figures to the surrounding space and the areas of space in between are far from being fortuitous or natural. Stress has clearly been laid upon attitudes and relationships. Everything has obviously been carefully pondered. Everything is governed by fixed *laws*. Even the light, uniformly strong over the whole canvas, differs from natural light.

Such a painting is in a high degree true to life and yet, as a result of definite intentions on the part of the painter, it differs from nature. Why? Because the artist was working according to artistic and aesthetic laws (constructively organizing) and not purely from the point of view of

•) The artist is, of course, entirely free to make use of any science (e.g., mathematics), any technique (e.g., printing-press, machine, etc.) and any material whatever, to achieve this exactitude.

natural objective legibility. The painter was more concerned about aesthetic purposes than about natural forms (Fig. **25**).

Instead of allowing the picturesque fortuitousness and diversity of nature to predominate, he seeks to achieve expression of a universal idea by purposeful organization of the figures and subordination of the details. Thus he appears to neglect the laws of nature in favour of those of artistic creation. He uses natural forms only as a means of attaining his artistic aim●).

The aim is: to create a harmonious whole in which the equilibrium of the whole, an aesthetic unity, is achieved by means of multiple exchanges and by cancelling out the positions and postures of the figures, the areas of space and masses and lines of movement in the picture (by relationships).

Indeed up to a point this artistic harmony is achieved. Up to a point, because the artistic aim is not sought directly through the artistic means, but only indirectly, obscured behind natural forms. Neither colour nor form appears in its pure state as colour and form. Rather colour and form are used to assist in producing an illusion of some other thing, e.g., leaves, glass, limbs, silk, stone, etc.

Such a work of art is the artistic idea expressed by naturalistic means.

It is an aesthetic-naturalistic work of art.

It deviates from external nature in so far as it is aesthetic (more inward); it deviates from the aesthetic idea in so far as it is naturalistic. It is, so to speak, split and is thus not an *unambiguously and exactly* formative work.

The aim of the formative artist is simply this: to give form to his

●) What the decadents of Cubism with their 'superrealism' are now almost without exception aiming at is exactly the same thing: a classical, painterly harmony achieved by means borrowed from nature. That in this process the natural forms are not intended as such but are to be regarded only as objective phenomena, makes, from the artistic point of view, no fundamental difference. One might label this movement Neo-Baroque.

aesthetic experience of reality or, one might also say, his creative experience of the fundamental essence of things. The visual artist can leave the repetition of stories, fairy-tales, etc., to poets and writers. The only way in which visual art can be developed and deployed is by revaluing and purifying the formative means. Arms, legs, trees, and landscapes are not unequivocally painterly means. Painterly means are: colours, forms, lines, and planes.

Taking the development of visual art as a whole, we can, in fact, see the means becoming increasingly clearly defined and providing the possibility of purely formative expression for the artistic experience. Since these formative means have made their appearance as the principal visible factor, everything in painting, sculpture, and, to some extent, in architecture which has no immediate place among the purely expressional means has been relegated to the background (Fig. **26**).

It is unnecessary to record every stage in the development of their importance in the evolution towards an exact artistic expression●). We may summarize all these various currents, whether or not they belong to systems as: the conquest of an exact expressional form of the aesthetic experience of reality.

The essence of the formative idea (of aesthetics) is expressed by the term *cancellation*.

One element cancels out another.

This cancelling out of one element by another is expressed in nature as well as in art. In nature, more or less concealed behind the accidents of the particular case, in art (at least in the exact, formative kind), clearly revealed.

●) I would refer those who are interested to: *Von Monet zu Picasso*, Max Raphael, Delphin-Verlag, Munich 1913. *Modern Painting*, W. H. Wright, 1917. *De nieuwe Beweging in de Schilderkunst*, Theo van Doesburg, J. Waltman, jr., Delft 1915, and *Classique-Baroque-Moderne*, Edition de l'Effort Moderne, Paris 1920. *Neue Gestaltung*, P. Mondrian, Bauhausbücher 5, Albert Langen Verlag.

Although we cannot grasp the perfect harmony, the absolute equilibrium of the universe, each and everything in the universe (every motif) is nevertheless subordinated to the laws of this harmony, this equilibrium. It is the artist's business to discover and give form to this concealed harmony, this universal equilibrium of things, to demonstrate its conformity to its own laws, etc.

The (truly exact) work of art is a metaphor of the universe obtained with artistic means.

We saw in example **5** that artistic equilibrium was achieved in the work of art of an earlier age by the repeated cancelling out of one figural position by another, one dimension by another, etc.; by, therefore, a reciprocal cancelling out of *means borrowed from nature.*

The great step forward made by the exact formative work of art consists in the fact that it achieves aesthetic equilibrium by pure artistic means and by these alone.

In the exact, formative work of art the formative idea is given direct and actual expression by continual cancelling out of the expressional means: thus a horizontal position is cancelled out by a vertical one, similarly dimension (large by small) and proportion (broad by narrow) (Fig. **27**). One plane is cancelled out by another which circumscribes it or one which is related to it, etc., the same applies to colour: one colour is cancelled out by another (e.g., yellow by blue, white by black), one group of colours by another group of colours and all coloured planes are cancelled out by non-coloured planes and vice versa•). (Fig. **9, 10, 11**). In this way (according to Piet Mondrian: 'Neue Gestaltung' in the *Bauhausbücher*, Vol.5), by means of a constant cancelling out of position, dimension, proportion and colour, a harmonious overall relationship, artistic equilibrium, is achieved

•) In Impressionism this cancelling out was expressed intuitively. In order to achieve a harmonious impression one colour was cancelled out by another. Hence the expression: colour-relationship.

and with it, in the most exact manner, the aim of the artist: to create a formative harmony, *to give truth in the way of beauty*. The artist no longer embodies his idea by indirect representation: symbols, slices of life, genre scenes, etc.; he gives form to his idea directly and purely by the artistic means available for the purpose.

The work of art becomes an independent, *artistically alive* (plastic) organism in which everything counterbalances everything else.

FIFTH CHAPTER

THE RELATIONSHIP OF THE OBSERVER TO THE WORK OF ART

Art is expression. Expression of our artistic experience of reality. Formative (visual) art is formative expression with formative means.

The art of music is musical expression with musical means.

Some people are capable of understanding this expression immediately and without preparation, others need intellectual preparation and special initiation. An unconscious or subconscious relationship with the work of art does not satisfy them, they want a clearly conscious attitude.

In order to acquire this conscious relationship with the work of art, which, as emerges from this study, can obviously be only a consciously artistic one, it is necessary to grasp the concept of formative art in its fundamental significance as we have explained it in the foregoing chapters.

These show that in exact, formative art it is possible to express the artistic experience of reality simply and solely with the means proper to each branch of art – in painting, for example, with colour and its relationship to the picture plane. Anyone who doubts this possibility had better keep to indirect art, which is only secondarily 'formative', in which the artistic idea is uncertainly expressed because other combinations of ideas are present.

Those who do not doubt this possibility must, from the historical and aesthetic point of view, regard this exact, formative art as the logical continuation of the development of visual art up to this time. In the visual art which has existed until now, the artist has not confined himself to formative means but has used other means as well.

He has used literary, symbolic, religious means or means in which ideas were evoked by an object, so as to give his work an 'intellectual' accent.

As the creation of an original image is to copying, as writing a story is to telling it, as composing a song to singing it, so is exact formative art to art which is not exact but contains associative ideas.

If the observer's relationship to a classical work of art is not artistic but is of another kind, e.g., purely religious or based upon sensory involvement, this observer's relationship to an exact work of art must clearly be the same. Practical experience has shown me that this is in fact so.

Example 6

Once when I was with someone visiting a museum in which Greek and Egyptian sculpture was displayed, I became aware that my companion was admiring only the Greek sculpture while the Egyptian left him indifferent. In the presence of the Greek sculptures he could not find words to express his enthusiasm for the 'splendid bodily forms which betokened health and vitality'.

The juxtaposition of bodily forms and their harmony gained his admiration more readily than did the combination and harmony of the broadly conceived planes and dimensions of the Egyptian sculptures. In these sculptures he admired only irrelevancies. He tried to decipher them by graphological methods as though they were some symbolic writing. Looking at the reliefs, he tried to reconstruct the life and customs of the people from the events portrayed.

Later when I showed him two modern pictures in one of which a few playing cards had been used in the composition, he commented 'skat party'. The other picture, in which the composition was carried out in purely painterly terms, by confronting rectangular planes without any reference to perceptible natural objects, he described as a box of bricks.

In all four cases, with the Greek and Egyptian sculptures as well as

with modern pictures, his imaginative faculty was working within a purely sensory nexus.

The manner in which he reacted to the Greek sculptures may be called sensory and associative, because his attention was fixed upon the shapeliness of the bodily forms which he measured directly against their relationship to reality and the bodily forms he had observed in the real world.

The manner in which he reacted to the Egyptian sculpture was sensory and associative because he related the forms and symbols he saw directly with reality (the Nile, sun, moon, agriculture, etc.)

His attitude to the first of the modern pictures was sensory and associative because the optically perceptible subject – playing cards – immediately suggested to him the idea of a skat party.

His reaction to the exact, formative work of art must be called sensory and associative because his optical perception was confined to the sensorily perceptible artistic means, which, because they used rectangular planes, awoke in his imagination the idea of a child's toy he had observed in reality, a box of bricks.

It was not the purpose of the four creators of these works of art to arouse a purely sensory and associative gratification (there are even painters – the painter of the example just quoted was one – who alternate sensory and associative gratification with artistic stimulation); these artists were solely concerned with exteriorizing their intellectual (aesthetic) experience of reality. We may therefore conclude with a clear conscience that the person in my example is *incapable of an artistic (aesthetic) relationship with a work of art, exact or inexact.*

Since, usually because they have been badly trained in receptivity, people who come into contact with art (music, visual art, literature, etc.) react in the manner described above, that is, sensorily and associatively, it may be said without exaggeration (in view of the innumerable and daily multiplying examples) that where art in general is concerned the means

is taken for the end and that the relationship of many people with the work of art is a relationship with the artistic means and not a relationship with art in its essence. The artist's ultimate aim, the artistic content, the aesthetic compositional accent, is usually entirely overlooked.

If the relationship with the work of art is a sensorily associative one rather than an intellectually associative, an aesthetic one, clearly most people's relationship with the new exact formative mode in painting and sculpture will not be of the kind essential for any work of art, let alone for one in the exact mode.

If the layman – and by layman I mean in this context anyone who, because of bad training, reacts to a work of art in a purely sensorily associative manner – who looks at a picture by Nicolas Poussin still adopts a sensory attitude (through the persons, figures, trees, houses, landscape, etc.), he cannot adopt such an attitude with an exact work of art; unless his relationship be only with the means. Thus it may, for example, happen that someone looking at an exact work of art feels himself pleasantly moved in a sensory way (his taste being involved) by the colour effects. This, of course, has nothing to do with an artistic relationship with the work of art.

XXII. Aesthetic understanding of an exact work of art is possible only when the observer has exclusively aesthetic relationships with works of art.

This means: As he looks at the work of art the observer must be able to re-create it in his consciousness●).

To admire the light in a painting by Rembrandt is equivalent to going into ecstasies over the velvet and silk in a painting by Cornelis Troost or over the shine on the dress boots in one by Anton von Werner.

Were it possible for such an attitude to serve as yardstick for the proper

●) Not: *reconstruct* its subject. Many people naïvely believe that they have fully understood a modern work of art as such once they have managed to recognize the objective theme which inspired the artist.

understanding of the true work of art, *The Night Watch* and an official group-portrait by Troost, in the case of Rembrandt and Troost, would be essentially in the same class. But, essentially, their work is totally dissimilar. With Rembrandt, light, silk, etc. are the means of expression (of an artistic and aesthetic attitude), with Cornelis Troost the representation of the silk is the *aim*.

Rembrandt sought, by means of darkness and light, to suggest a space formation which is *painterly* and different from real space. Cornelis Troost wished to simulate silk by means of colour.

Now when somebody looking at a painting by Rembrandt observes the way in which the painter uses repeated exchanges, interpenetration, and the cancelling out of one element by another (in this instance of light by darkness, colour by contrasting colour, etc.) and sees therein the painterly formation after which Rembrandt was striving *as it were really 'coming into existence'*, he has apprehended the artistic root of the painting. In this manner the observer himself shares inwardly in the creation and to this extent the process may be described as a new re-creation in the consciousness of the observer.

This, the *creative* way, is the only true way of looking at visual art. There is none other, either for classical or for modern art.

In classical art the artistic aim is more or less concealed behind supervening auxiliary means. In modern art the artistic aim always appears with greater clarity, greater exactitude. There are always fewer anecdotes and borrowings from nature to deflect the observer from the artistic aim and thus the demand upon him to re-create the work anew (the aesthetic re-creative activity) is stronger. He must adopt a more active attitude towards the work of art if he wishes to understand it properly.

Example 7

It must be most firmly stressed that when he is looking at an exact

work of art the observer does not perceive specific, that is dominant, details. The impression is rather one of complete equality of importance of all the parts, a concept which concerns not only these parts as such, but must be carried over to the relationship between the observer and the work of art. Difficult though it is to express in words the effect of a work of art, the observer's deepest perception is still best described by saying that a balancing of the subjective and the objective takes place within him, directly imbued with an emergent awareness, and he experiences a sense of clarity, of simultaneous height and depth, which has no connexion with natural relationships or spatial dimensions, a perception which removes the observer to a state of conscious harmony, in which the action of separate dominants is resolved.

It is not impossible that this artistic vision resembles religious harmony or exaltation, because the inmost essence is expressed in the work of art, but with the fundamental difference that *artistic* contemplation, emergent awareness and exaltation – in a word: the pure *artistic experience* – has nothing fanciful and vague about it; on the contrary: the true artistic experience is wholly *real and conscious*.

Genuine artistic experience cannot be passive for the observer is compelled as it were to experience with the artist the continual and repeated exchange and cancelling out of position and dimension, lines and planes. He will understand how harmonious relationships finally spring from this play of recurrent exchange and cancelling out of one element by another. Each part unites with other parts. *The formative unity of the whole grows* out of all the parts (but single parts of the whole do not dominate and stand out).

A perfect equilibrium of artistic relationships has been achieved. There is nothing to deflect the observer; he is free to participate in it.

ILLUSTRATIONS

**THE ELEMENTARY
EXPRESSIONAL MEANS
OF PAINTING**

Negative Positive

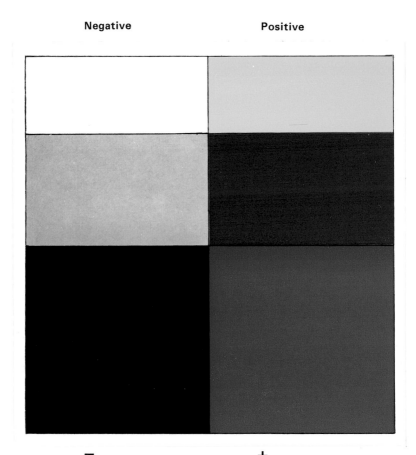

Fig. 1

− +

THE ELEMENTARY EXPRESSIONAL MEANS OF SCULPTURE

Positive = volume
Negative = emptiness

Fig. 2

THE ELEMENTARY EXPRESSIONAL MEANS OF ARCHITECTURE

Positive: line, plane, volume, space, time
Negative: emptiness, material

Fig. 3

Fig. 4

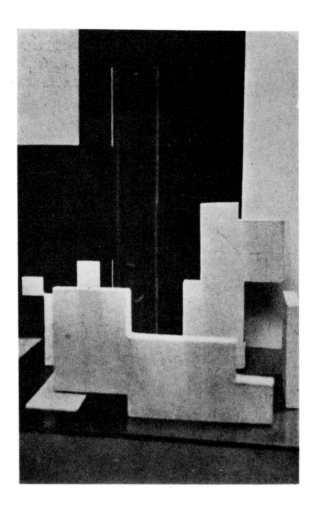

CONSTRUCTION SYNTHESIZING THE VARIOUS
ELEMENTARY PLASTIC MEANS:

| Colour, line, plane, volume, space, time |

A R C H I T E C T U R E

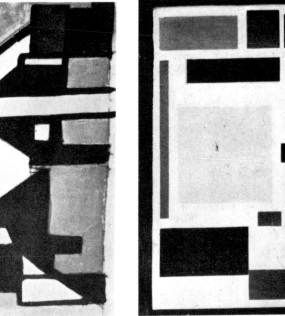

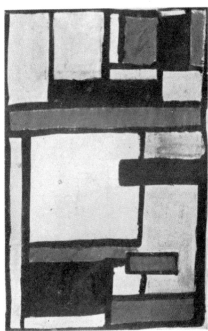

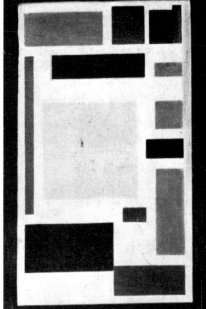

AN OBJECT AESTHETICALLY TRANSFIGURED
Fig. 5: Photograph. Fig. 6: Form preserved but relationships accentuated. Fig. 7: Form abolished. Fig. 8: Image

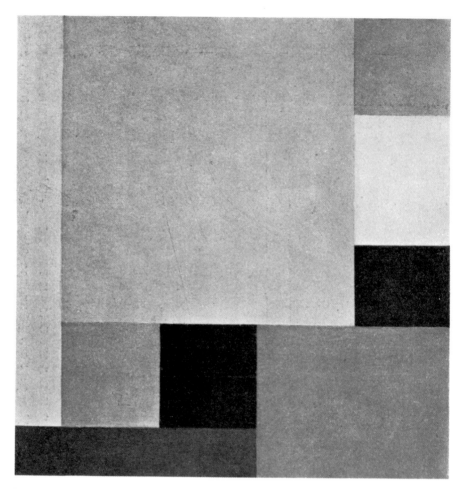

THEO VAN DOESBURG (1921) Comp.21
Fig. 9

COMPOSITIONS CONSTRUCTED WITH
ELEMENTARY MEANS (Fig. 9,10,11)

Fig. 10
G. VANTONGERLOO

Sculpture II (1918)

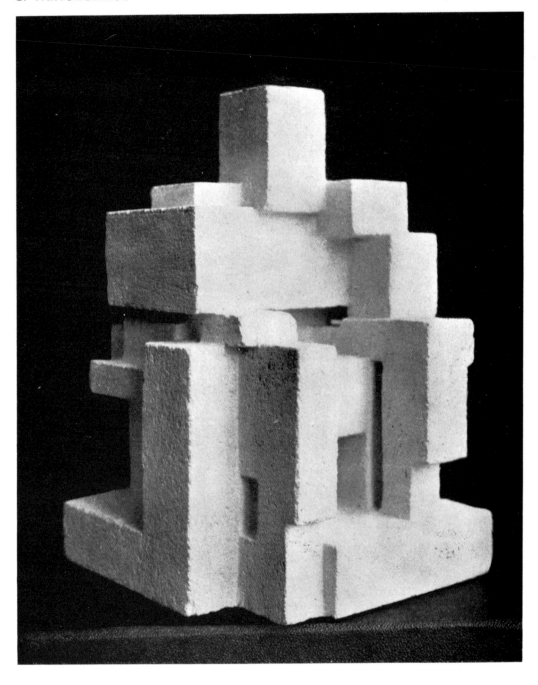

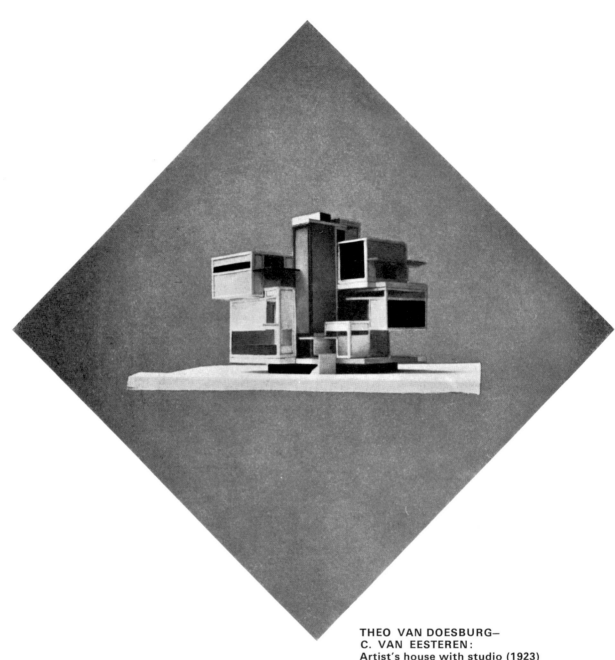

THEO VAN DOESBURG—
C. VAN EESTEREN:
Artist's house with studio (1923)
Fig. 11

THEO VAN DOESBURG
Drawing (1906)

Fig. 12

THEO VAN DOESBURG:
Beggar (1914)

EXPRESSION OF AESTHETIC ACCENTS RENDERED INDE-
TERMINATE BY ADMIXTURE OF PERSONAL, INDIVIDUALIS-
TIC, HUMAN ELEMENTS

Fig. 13

THEO VAN DOESBURG:
Aesthetic reconstruction of a nude (1916)

Fig. 14

THEO VAN DOESBURG:
Space-time reconstruction of the same (1916)

Fig. 15

Fig. 16 THEO VAN DOESBURG (1916) Study

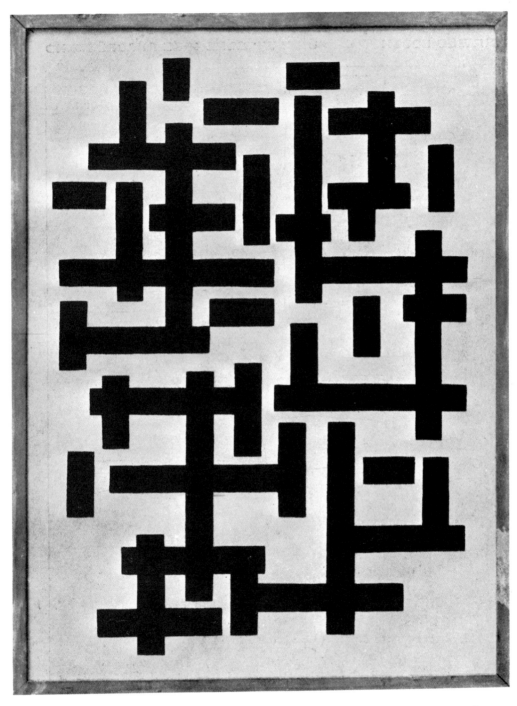

Fig. 17 THEO VAN DOESBURG (1916) Image

Fig. 18
HIERONYMUS BOSCH PREDOMINANTLY EXPRESSIVE OF IDEA

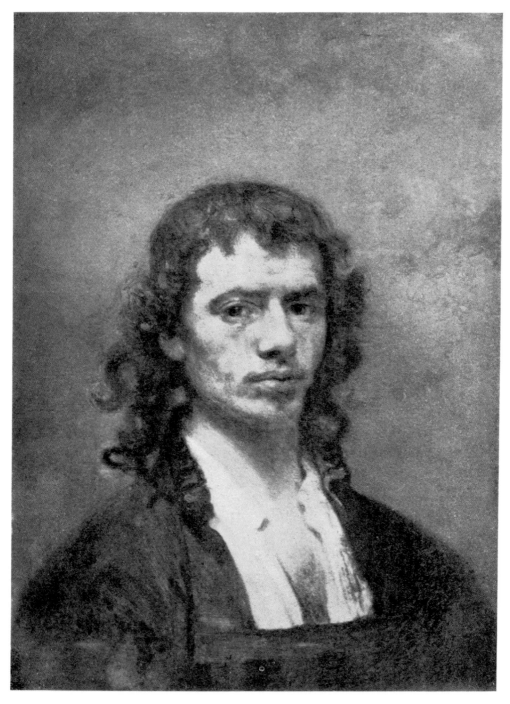

Fig. 19 FABRICIUS (School of Rembrandt): Self-portrait
PREDOMINANTLY EXPRESSIVE OF MATTER

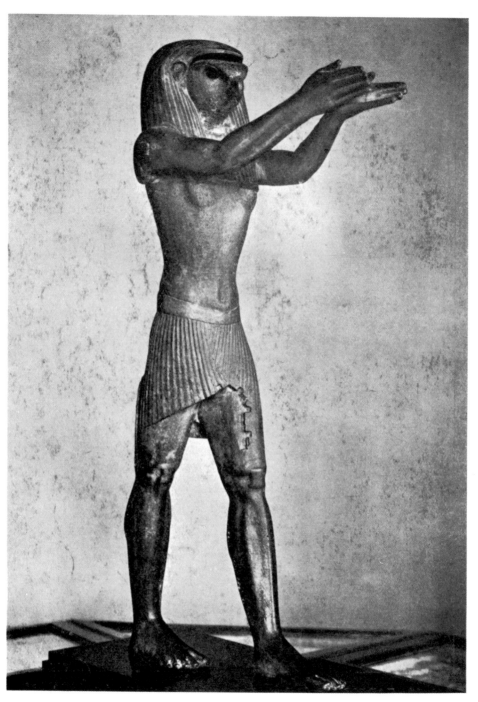

Fig. 20 HORUS (Egyptian) EXPRESSIVE OF IDEA

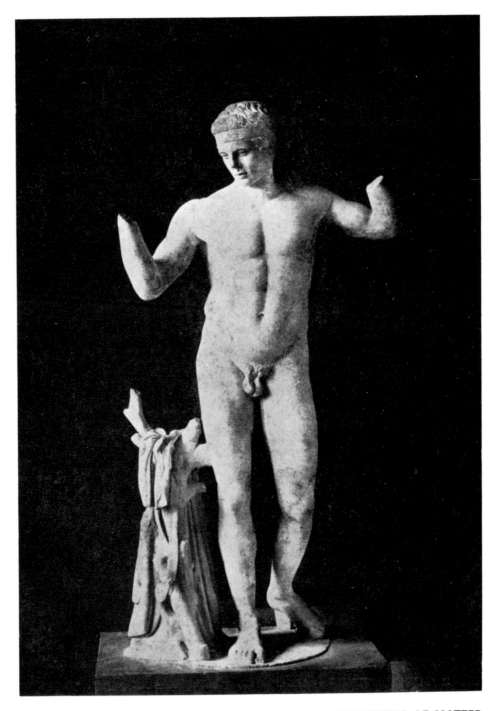

Fig. 21 DIADUMENOS (Greek) EXPRESSIVE OF MATTER

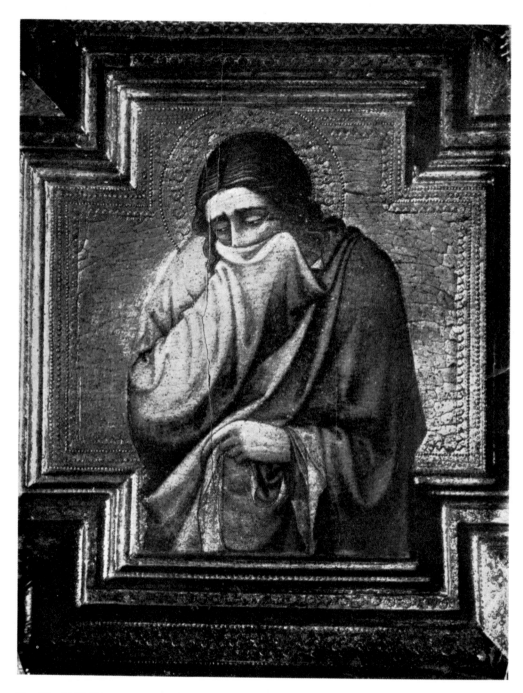

Fig. 22 MEDIEVAL PAINTING (Italian)

Fig. 23 AUGUSTE RODIN: La pensée DUALITY OF MATTER AND PLASTIC FORM

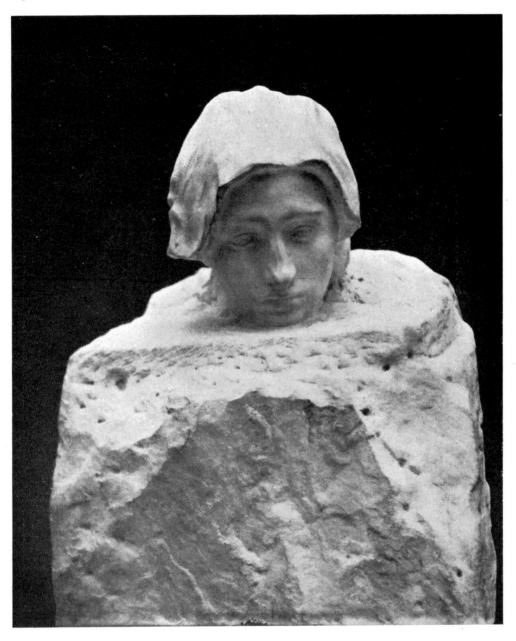

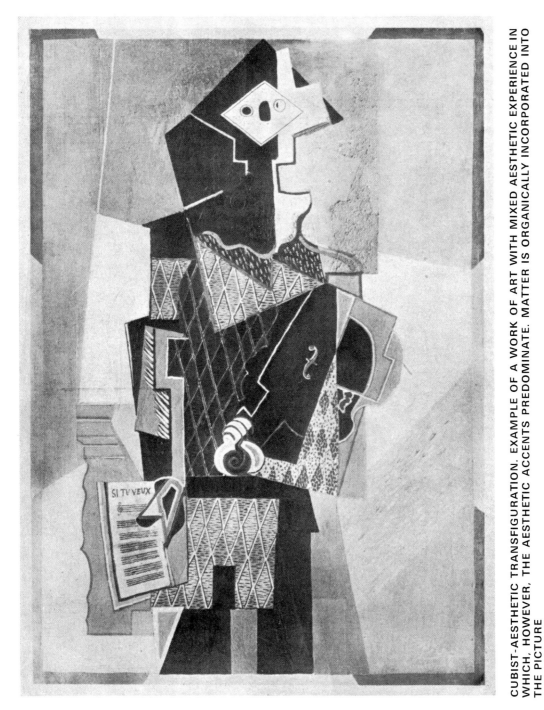

Fig. 24 P. PICASSO: Man with violin (1918)

Fig. 25 NICOLAS POUSSIN: Shepherds in Arcady

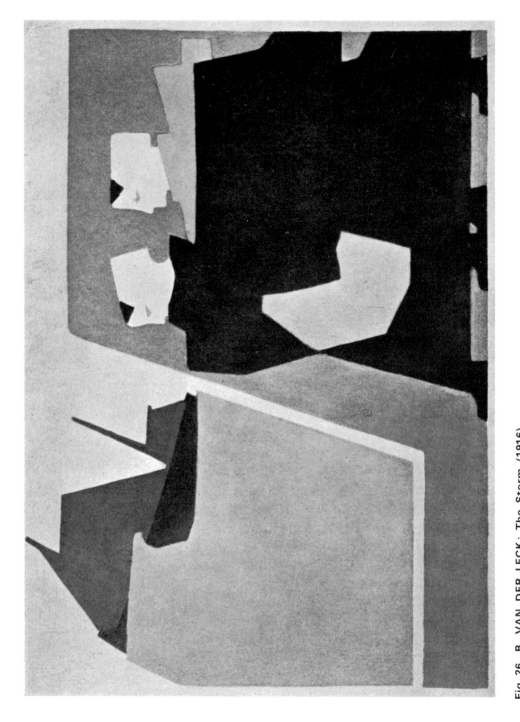

Fig. 26 B. VAN DER LECK: The Storm (1916)
MAINLY AESTHETIC EXPERIENCE. THE SECONDARY, ILLUSIONIST MEANS ARE COMPLETELY SUBORDINATED TO THE PAINTERLY CONSTRUCTION

3 PHOTOGRAPHS STARTING FROM UNFORMED NATURE AND PROGRESSING TO ENHANCED FORM REALIZED IN LIGHTS

Fig. 28 NATURE (aerial photograph)

Fig. 29 CULTIVATION

Fig. 30
PLASTIC FORM (Advertisement in
neon lights, New York. Photograph
Lönberg-Holm)

Fig. 31
THEO VAN DOESBURG
C. VAN EESTEREN:
Model for a villa (1923)

Fig. 32
Colour used with an overall formative purpose in a hall by **THEO VAN DOESBURG** in
C. VAN EESTEREN'S university building (1923) (Project)

ORGANIC SYNTHESIS OF PURE EXPRESSIONAL MEANS IN ARCHITECTURE

← exterior | interior

POSTSCRIPT

H. L. C. JAFFÉ:
THEO VAN DOESBURG

As a creative artist, as founder of the De Stijl group, as an intellectually alert personality, and as a man of practical action Theo van Doesburg has set his stamp distinctly upon the twenties of the present century. The fifteen years of his creative activity, from 1916 until his early death in 1931, have left their mark upon the history of modern art — and that in the most widely separated fields. Versatility, an influence exerted in many directions, is highly characteristic of Van Doesburg's artistic personality. Were Theo van Doesburg and his achievements to be regarded from only one aspect of his artistic talent, his image would be distorted and an injustice done to modern art.

Theo van Doesburg was born in Utrecht in the year 1883. His original bourgeois name was C. E. M. Küpper; but he very early assumed the artist's name, under which — far beyond the frontiers of his own country — he was to become at once a controversial figure in the field of modern art and a symbol of an unyielding desire for renewal. He thus belonged to the generation which produced so many of the pioneers of modern art: he was two years younger than Picasso, a year younger than Braque and Stravinsky, and the same age as Gropius and Erich Heckel. He was, however, a relative latecomer among the champions of modernism in Holland: Theo van Doesburg was considerably younger than the poets and men of letters who gave a new impetus to Dutch culture in the 1880's and even some of his colleagues in 'De Stijl' were a few years older than he. Mondrian was born in 1872, Van der Leck in 1876.

Theo van Doesburg began to study painting when he was sixteen. Response to the work of the gifted young artist came early; by 1908, when he was twenty five, he was in a position to hold his first exhibition in The Hague. His talent, however, was not only for painting. Thus he was working — certainly in 1912 — as an art-critic for various newspapers and periodicals, in particular for *Eenheid*, a progressive paper which had just been founded. As a critic, Theo van Doesburg gathered information about contemporary events in widely differing fields of art. He was one of the few connoisseurs in Holland who was familiar with Kandinsky's painting, knew about

his resolute conversion to abstraction, and was conversant with his aesthetic views as set forth in his book *On the spiritual in art*.

The first world war — which meant full mobilization for the neutral Netherlands — interrupted the promising development of the young artist and critic. Theo van Doesburg was conscripted into the Frontier Guard; he served in the army from the summer of 1914 until mid-1916. His friendship with Antony Kok, whom he met and came to esteem during his military service, dates from this time.

As soon as he was demobilized in 1916 Van Doesburg embarked upon intensive artistic activity, constantly embracing new spheres and possibilities of artistic work — an activity which persisted until his early death. It is characteristic of him that he conducted architectural experiments alongside his painting. Van Doesburg's collaboration with the architects J. J. P. Oud and Jan Wils, which found expression in the community of 'de Sphinx', dates from this first year of his free development. Friendly and artistic contact with Oud grew closer in 1917 when the two were working on Oud's villa at Noordwijkerhout, for the interior decoration of which Van Doesburg designed a number of coloured motifs. This intellectual climate — a strong interest in architecture and at the same time an intensive preoccupation with painting in its most progressive strain — resulted in the founding of the De Stijl group, which may well be regarded as Theo van Doesburg's most important action and the most far-reaching from the point of view of cultural history.

A friendship had grown up between Theo van Doesburg and the painters Piet Mondrian and Bart van der Leck, who were then working in Laren; Van Doesburg often visited them in their studios and the three painters exchanged experiences, pooled their achievements, and in this way evolved a new style. On the strength of this, Van Doesburg, together with Mondrian and the painter Vilmos Huszar, the architect J. J. Oud and the essayist Antony Kok, started the group 'De Stijl'. They were joined almost at the same time, 1917–18, by Bart van der Leck, the Belgian sculptor Georges Vantongerloo, and the Dutch architects Jan Wils and Robert van't Hoff. In August 1917 the 'De Stijl' group made its first public appearance with its journal of the same name. In November 1918 the first 'De Stijl' manifesto appeared with its stirring opening words: 'There is a consciousness which belongs to the old days and another which belongs to today. The old one is aligned with the individual. The new one is aligned with the universal. The struggle of the individual against the universal is as apparent in the world war as it is in the art of our time.'

70

These artists, especially Van Doesburg, continually and emphatically stated, both in theory and in practice, that their aim was absolute universality; the whole activity of the group was, however, in the end determined by this programmatic claim. The paintings of the De Stijl group — abstract, based upon extreme limitation of the plastic vocabulary, composed of straight lines, the right angle, the three primary colours, and the three primary non-colours — are, like the first achitectural designs and the early De Stijl sculpture, avowals of a universal harmony. To a very large extent this radically reduced vocabulary excludes individual effusions, so that by and large the work of the De Stijl group looks like a collective *oeuvre*. The De Stijl principles of universality are expressed particularly clearly in Van Doesburg's work, for between 1917 and 1920, he produced, besides painting, certain works which overlap into the field of architecture and sculpture; in 1919 he designed an abstract monument for Leeuwarden, while in 1920 he made architectural designs for Drachten. That his orientation was universal became apparent during his stay in 1921 and 1922 in Germany, where his influence was far reaching, largely due to his Weimar lectures.

To enumerate these activities — all of which tend in the same direction — is, however, by no means to exhaust the account of Van Doesburg's versatility. During the very years in which he was working to realize and to spread the ideas of De Stijl, he was labouring in his capacity of poet and essayist to create a platform for Dadaism in Holland. For the purpose of publishing his sound-poems and his polemical essays he took upon himself a second and third identity — the pseudonyms I. K. Bonset and Aldo Camini. He published *Mecano*, a Dadaist pamphlet which survived through three numbers, under his own name.

During the following years Van Doesburg developed renewed interest in architecture. A commission from the Paris art-dealer Léonce Rosenberg brought together three members of De Stijl — Van Doesburg, Van Eesteren and Rietveld — on the work of preparing a series of projects for an artist's house and a private house. Like De Stijl painting in 1917, these projects were designed to reduce architecture to its elements; they put forward entirely new, revolutionary solutions to the questions of space, spatial clarity, and order. The designs were exhibited in Paris and later in Weimar and Nancy. Rietveld's celebrated house in Utrecht dates from the same period and provided an opportunity of realizing much of what had been prepared in the projects.

Van Doesburg's work in architecture, in balancing masses and in designing in

71

perspectival projection, now influenced his painting once more. Van Doesburg's *Contra Compositions*, and a number of paintings for which in a manifesto of 1926 he found the name *Elementarism*, date from 1924. The distinguishing feature of these paintings is that their linear scaffolding – consisting of lines intersecting at right angles – is placed diagonally on the picture plane, thereby achieving a more dynamic effect. Van Doesburg's *Elementarism* appeared to Mondrian, his friend and fellow-worker, to be a deviation from the high and austere principles of De Stijl. Thus Van Doesburg's dynamic innovation caused a breach between the two most important artistic personalities of the De Stijl movement.

But it was precisely Van Doesburg's *Elementarism* – the painting which imbued the basic principle of De Stijl with a new dynamic – which proved to be a possible new point of departure and jumping-off ground for a marriage of painting and architecture. In the year 1926 Van Doesburg received a commission to design the interior of the café-restaurant 'L'Aubette' in Strasbourg; he carried out the commission in 1927 and published the results in a special number of the journal *De Stijl* in the following year. The interior, which unhappily succumbed during the second world war to the crazy ideas of the National Socialists about *'Kunst'* and *'Unkunst'*, was an important monument of twentieth-century space formation; the way in which colour was used in a manner far transcending its decorative purposes as an additional means of creating the spatial structure and of defining the space became an example to others. Colour became an indispensable part of the plastic space. After he had completed 'L'Aubette' Van Doesburg worked simultaneously at painting and architecture. On the one hand he took his elementary painting a stage further and gave it a scientific basis, creating his first 'arithmetical compositions' in 1930 – and on the other, the spirit of precision which informed his painting took shape in the last great product of his architectonic efforts, the plans for his own house at Meudon-Val Fleury. The house, designed both as a home for himself and as a collective studio for the De Stijl group, was still unfinished when Van Doesburg died in Davos on 7 March 1931. He was not yet forty eight.

Who then was this fascinating, controversial, compelling figure who not only created a significant *oeuvre* of paintings and buildings of his own, but, throughout the few years granted him for work, always gave in vital ways to others and was the centre of an artistic movement? Who was the man who, as animator and spiritual father, not only created the De Stijl group but also subscribed to Dadaism and to

72

the advancement of architecture? Finally, in Paris during the years round 1930 — and as a member of the 'Art concret' and 'Abstraction-création' groups — Van Doesburg made a lasting contribution to the spread of abstract art. Who was he — as artist and as man?

Antony Kok, one of Van Doesburg's oldest friends and collaborators in De Stijl, made the lapidary comment: 'Van Doesburg and Mondrian are the two pillars which form the gateway to a new world.' These words of Kok express the solidarity as well as the antagonism of the two outstanding figures of the De Stijl group. Van Eesteren in his obituary notice in the memorial number of the journal *De Stijl* — the last number to appear — further developed the theme of the contrasts and the shared qualities of these two personalities: 'Van Doesburg gave something new to life. He lived in a world to which few had access. Each in his own way, Van Doesburg and Mondrian — two great men who are not yet fully understood — tried to reveal the key image to his fellow men, Mondrian in his calm, static manner — Van Doesburg dynamically, as he expressed it: "to have the courage to go on destroying life in order continually to renew it, destroying our own self so that we may be able to build a new self".'

Beside Mondrian, whose life was imbued with the dream of a universal harmony and whose work gave expression to the Utopia of a brighter, clearer world, stands Van Doesburg, energetic and active, a man whose aspirations were not satisfied by working towards the goal of a world of the future regulated by the principles of harmony and universal equilibrium; he longed rather to organize and transform the world of his own day in the spirit of this harmony. This was why this gifted painter became an architect and why he invited architects to join the De Stijl group, as long as it existed. Theo van Doesburg wished always to build and to realize his projects. The structures of his imagination were the fruits of a new spirit which would depart from the outmoded forms of the past. He was a pioneer, a discoverer and an innovator and — as his works show — a man of action. The following appreciation was made in retrospect by Peter Röhl, one of his German pupils during the 1920's: 'I recognize Van Doesburg's strength in the many-sidedness of his work. There may have been stronger individual personalities in the individual arts during the age of development, but in the totality and completeness of his powers Van Doesburg towered above the most important figures of the movement.'

(Amsterdam, Summer 1965)

73

DATE DUE